THINGS WE
FORGET

THINGS WE FORGET

Little Reminders of What Matters Most

J. J. PENN

A PERIGEE BOOK

A PERIGEE BOOK
Published by the Penguin Group
Penguin Group (USA)
375 Hudson Street, New York, New York 10014, USA

USA | Canada | UK | Ireland | Australia | New Zealand | India | South Africa | China

Penguin Books Ltd., Registered Offices: 80 Strand, London WC2R 0RL, England
For more information about the Penguin Group, visit penguin.com.

THINGS WE FORGET

ISBN: 978-0-399-16519-1

First edition: October 2013

PRINTED IN THE UNITED STATES OF AMERICA

10 9 8 7 6 5 4 3 2 1

The publisher does not have any control over and does not
assume any responsibility for author or third-party websites or their content.

Most Perigee books are available at special quantity discounts for bulk purchases
for sales promotions, premiums, fund-raising, or educational use. Special books,
or book excerpts, can also be created to fit specific needs. For details, write:
Special.Markets@us.penguingroup.com.

3176 7070

For Riya.

January 2008. The world is in the grip of the big recession. People are losing their jobs. People are losing their life savings. Worst of all, people are losing hope.

One rainy Monday morning, late for work, I hopped into a taxi. The driver happened to be the most talkative man I've ever met—and the most pessimistic. In a seamless monologue, he complained about the weather, the government, the other drivers on the road, his family, inflation . . .

Feeling sorry for whoever will ride in the taxi next, I pulled out a sticky note and a pen, and wrote, "Have a dream." I left the sticky note in the car.

That was the start of *Things We Forget*. Every day since that gloomy taxi ride, I have written a message on a sticky note—a simple idea to inspire, comfort, or encourage, something that might seem obvious, but that in the rush of our hectic daily routines we tend to lose sight of. I take a picture of the note, and then place the original some-

where, anonymously. Online readers and their "likes" soon followed—three hundred by the second day. I watched with amazement as the numbers grew. Maybe many of us have a grumpy taxi driver inside our heads.

A few weeks later, as online traffic continued to build, I received an email from a reader, saying she had been thinking of killing herself that day. Then she happened to see a sticky note I had written, which said, "Even the longest day is only 24 hours." She said that stopped her from ending her life. Many others have also shared their stories of seeing the notes when they needed encouragement or perspective.

I continue to post a sticky note a day, in the world around me and online. Through it all, I have decided to stay anonymous. I'm not really sure why, but to a certain extent it could be that because in Singapore what I do could be looked upon as littering or, worse still, graffiti.

In this book you will find three hundred of the notes. In book form, they aren't as ephemeral as they are "in the wild." But I hope that it will help you remember the seemingly little but important things we all too often forget.

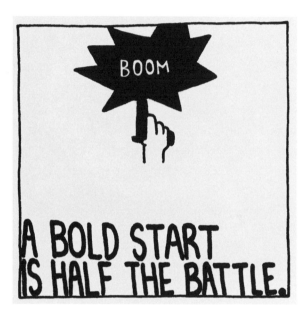

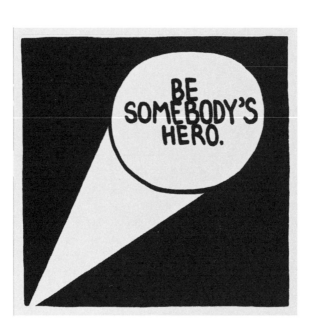

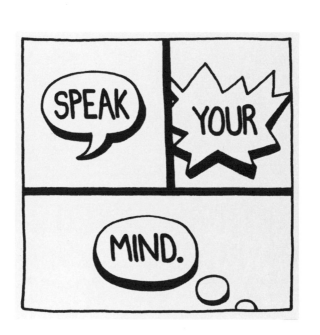

ANY PLACE
WITH A SHORTCUT
IS NOT
WORTH GOING TO.

TRY AND FAIL, BUT DON'T FAIL TO TRY.

SIMPLIFY
LIFE.

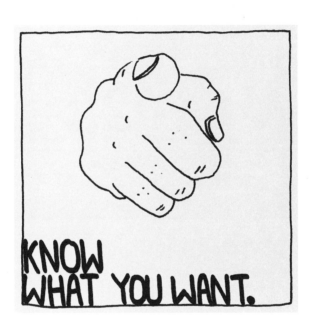

KNOW
WHAT YOU WANT.

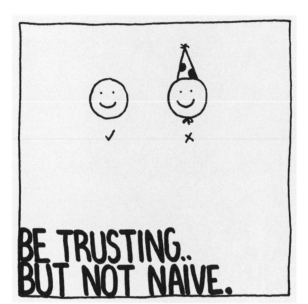

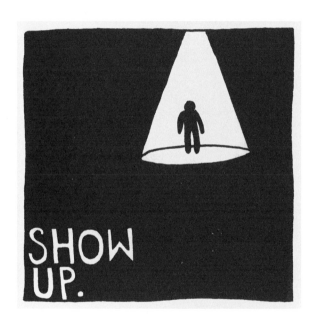

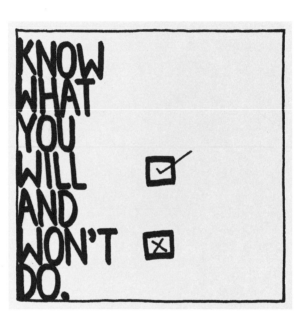

DON'T BE A
PERFECTIONITS.

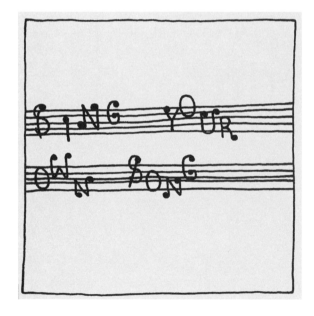

SING YOUR OWN SONG

KEEP
YOUR CO°L.

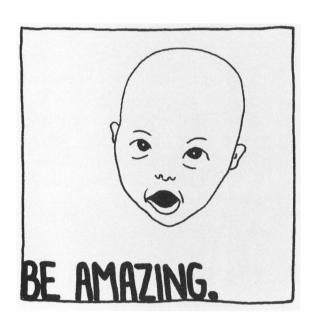

BE AMAZING.

INCREASE
YOUR HEARTBEAT.

≠

DON'T CONFUSE
THE UNTRIED
WITH
THE IMPOSSIBLE.

TINKER TAILOR SOLDIER SPY

WHATEVER YOU ARE
BE A GOOD ONE.

BY I WILL

MAKE
A DEADLINE FOR
YOUR DREAMS, AND
THEY BECOME GOALS.

$$\frac{\text{TAKE}}{+ \text{CALCULATED}} = \text{RISKS.}$$

ALL OBSTACLES ARE
EITHER IMAGINARY
OR TEMPORARY.

THERE'S A SMILE
RIGHT UNDER
YOUR NOSE. USE IT.

← THINGS YOU →

WHEN THINGS
GO WRONG
DON'T GO WITH THEM.

TAKE CHARGE
OF YOUR
OWN DESTINY.

IMPROVE
SOMETHING.

PURSUE
YOUR
PASSION.

LABOR AND WAIT.

TREAT
YOURSELF
KINDLY.

REMOVE ~~FAILURE~~ FROM YOUR VOCABULARY.

YOU ONLY RUN
OUT OF CHANCES
WHEN YOU STOP
TAKING THEM.

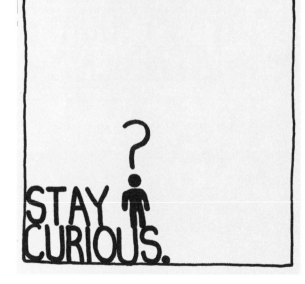

STAY CURIOUS.

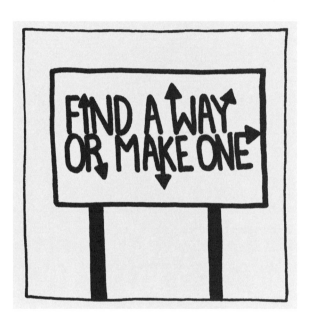

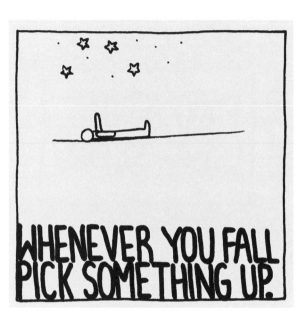

ARGUING WITH A FOOL PROVES THERE ARE TWO.

GET MAD,
THEN GET OVER IT.

EXPERIENCE
IS A GREAT
TEACHER. DON'T
SKIP HER CLASSES.

CULTIVATE PATIENCE.

PUT YOUR FUTURE
IN GOOD HANDS:
YOUR OWN.

BE A PART OF SOMETHING BIGGER THAN YOURSELF!

FIND A NEED AND FILL IT.

☒ GOOD

☑ GREAT

GOOD IS NOT
GOOD ENOUGH.

SATISFY NEED,
NOT GREED.

LOVE
WITH ABANDON.

KEEP ON
KEEPING ON||||||||||

THE ONLY
HELPING HAND
YOU NEED IS
AT THE END
OF YOUR ARM.

KIND < KINDER < YOU

ALWAYS BE
A LITTLE KINDER
THAN NECESSARY.

BE THE LAST TO FIGHT, AND THE FIRST TO MAKE UP.

WHATEVER...

FORGIVE AND FORGET.

BUILD CASTLES IN THE AIR AND THEN BUILD THEM FOUNDATIONS.

WHEN YOU GET TO
THE END OF YOUR
ROPE, MAKE A KNOT
AND HANG ON.

KNOW
THE DIFFERENCE
BETWEEN
MONEY AND WEALTH.

FIX WHAT
YOU CAN,
FORGET WHAT
YOU CAN'T.

DON'T WAIT FOR CHANGE. CREATE IT.

PAIN IS
INEVITABLE. ☐ YES
SUFFERING
IS OPTIONAL. ☐ YES
☐ NO

TICK TICK TICK TICK T

EITHER YOU
RUN THE DAY OR
THE DAY RUNS YOU.

HAVE A SENSE
OF HUMOR.

TAKE

1

DAY AT A TIME.

KEEP
GROWING.

BE YOUR OWN
BEST FRIEND.

DON'T
JUDGE YOURSELF
THROUGH SOMEONE
ELSE'S EYES.

TAKE
FUN SERIOUSLY.

PUT YOUR
MONEY WHERE
YOUR MOUTH IS.

LOVE LIFE,
AND LIFE WILL
LOVE YOU BACK.

RISE
ABOVE

THE
LITTLE
THINGS.

IF YOU WANT
TO BE HAPPY,
MAKE OTHERS HAPPY

THINK
OF PROBLEMS AS
OPPORTUNITIES
IN DISGUISE.

BE SLOW TO TAKE OFFENSE.

HEAR EVERYONE OUT, BUT LISTEN TO A CHOSEN FEW.

1. DO THE DIFFICULT FIRST.

DO NOTHING
HALF-HEARTEDLY.

DON'T PICK THE CONVENIENT OVER THE RIGHT.

GO THE EXTRA MILE.

TURN
YOUR
'SHOULDS' ☐
INTO
'MUSTS' ☑

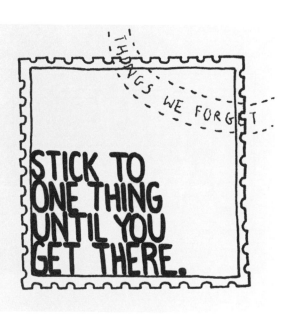

THINGS WE FORGET

STICK TO
ONE THING
UNTIL YOU
GET THERE.

THE TRUTH HURTS ONLY IF YOU RUN AWAY FROM IT.

YOU CAN'T SHAKE
HANDS WITH
A CLENCHED FIST.

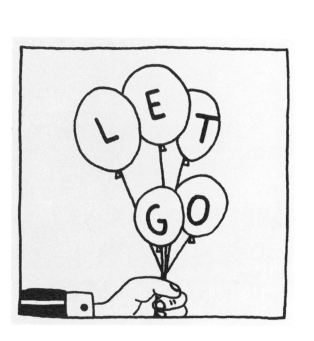

LET YOUR WORK
SPEAK FOR ITSELF.

KNOW YOUR
OWN WORTH.

DON'T STOP TO THINK
IF YOU'RE HAPPY,
AND YOU WILL BE.

BE
HERE
NOW.

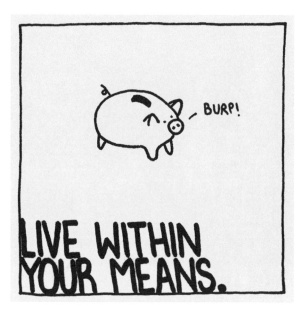

DON'T LOOK
BACK AND ASK WHY.
LOOK FORWARD
AND ASK WHY NOT.

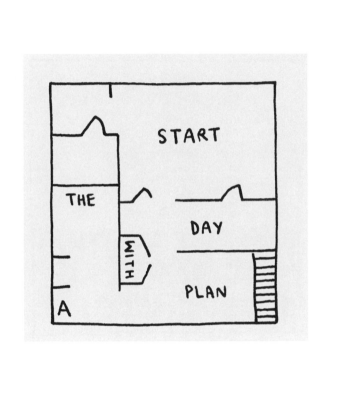

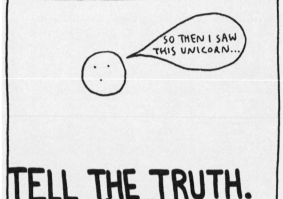

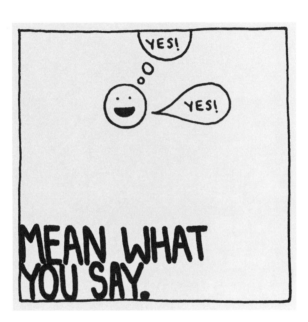

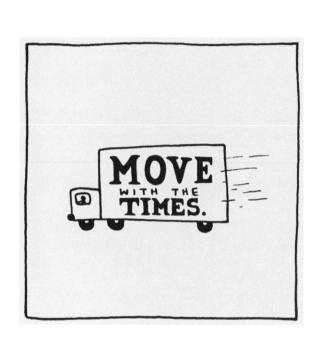

SAY IT
TO THEIR FACE
OR NOT AT ALL.

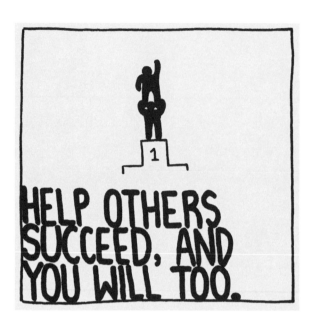

HELP OTHERS SUCCEED, AND YOU WILL TOO.

COMPETE ONLY AGAINST YOURSELF.

DON'T NEGLECT
THE SMALL THINGS.

LAY A FIRM
FOUNDATION
WITH THE BRICKS
OTHERS THROW
AT YOU.

TRY
ANYTHING ONCE.

DESTROY
YOUR ENEMIES
BY MAKING
THEM FRIENDS.

TRAVEL LIGHT
THROUGH LIFE.

PUT YOUR HEART
INTO WHATEVER
YOU DO.

BE YOURSELF.
EVERYBODY ELSE
IS ALREADY TAKEN.

"~~I PROMISE YOU~~
~~I WILL DO THIS THING~~
~~JUST LIKE YOU~~ DID."

THE SHORTEST
ANSWER IS DOING.

AWESOME ☑
SATISFACTORY ☐
AVERAGE ☐
POOR ☐

DO IT WELL
OR
NOT AT ALL.

ASK MORE OF YOURSELF.

GET UP ONE MORE TIME THAN YOU FALL.

DON'T WAIT FOR
EVERYTHING
TO BE PERFECT.

BE BETTER TODAY THAN YOU WERE YESTERDAY.

CELEBRATE
WHAT YOU WANT
TO SEE MORE OF.

BE WILLING
TO BE LUCKY.

RULE YOURSELF
AND YOU CAN
RULE ANYTHING.

HAVE
A WISHBONE,
A BACKBONE
AND A FUNNY BONE.

YOU MUST
LOSE A FLY
TO CATCH A FISH.

WORK
ON
HAPPINESS.

BE A
SELF-STARTER.

HOLD A TRUE
FRIEND WITH
BOTH YOUR HANDS.

IF YOU LEARN
FROM A ~~MISTAKE~~
IT'S NOT ONE.

IF NOT NOW,
THEN WHEN?
IF NOT THIS,
THEN WHAT?

WALK
IN SOMEONE
ELSE'S SHOES.

ATTEMPT
THE IMPOSSIBLE.

GIVE UP
THE NEED
TO BE RIGHT.

LOSE NOT YOUR
SENSE OF WONDER.

PROMISE LESS,
PERFORM MORE.

YOU > YOUR TROUBLES.

YOU'RE STRONGER THAN ANYTHING THAT CAN HAPPEN TO YOU.

MAKE TIME FOR YOURSELF.

BE BIGGER THAN YOUR CIRCUMSTANCES.

DON'T FIT IN,
STAND OUT.

LEAVE EVERYTHING
A LITTLE BETTER
THAN YOU FIND IT.

STICK
YOUR
NECK
OUT

ANGER
IS ONE LETTER
SHORT OF DANGER.

IMPROVEMENT BEGINS WITH "I."

IGNORE THE RAIN. LOOK FOR THE RAINBOW.

TREAT NEGATIVITY LIKE A DUCK TREATS WATER.

ONLY A MOUSETRAP
HAS FREE CHEESE.

FALL IN LOVE
AND STAY THERE.

DON'T LET SUCCESS GO TO YOUR HEAD, OR FAILURE TO YOUR HEART.

HOLD
NO GRUDGES.

THROW YOURSELF INTO WHATEVER YOU'RE DOING.

DON'T
LET FAILURE
DEFEAT YOU.

NEVER BE TOO
BUSY FOR THOSE
WHO LOVE YOU.

ATTITUDES
ARE CONTAGIOUS.
ARE YOURS
WORTH CATCHING?

ASK
THE RIGHT
QUESTIONS.

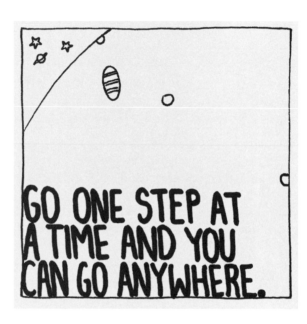

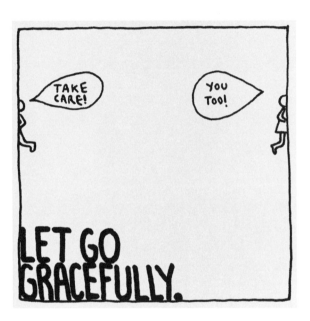

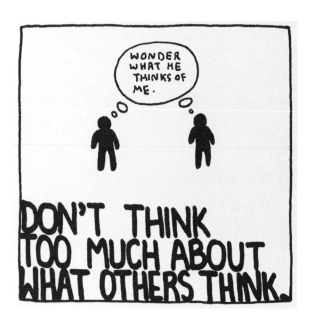

USE
TIME
WISELY

BE LAVISH
WITH (PRAISE)2
AND SPARING
WITH (CRITICISM)$^{1/2}$.

LEAVE ROOM FOR
HAPPY ACCIDENTS.

TODAY IS
THE FIRST DAY
OF THE REST
OF YOUR LIFE.

Thank You

To my wife, Asha—for her unconditional love, help, and support every single day.

To my parents, Chacko and Ann.

To my editor, Marian Lizzi, for believing in me and *Things We Forget*. And all the lovely folks at Perigee.

To my agent, Fran Lebowitz.

To Juggi Ramakrishnan, for being the first to spot the project's potential.

And finally, thank you very much to all my lovely friends online and offline, who spread the blog around the Internet and keep me going each day with your emails, likes, shares, and retweets. You've changed